HATED
BECAUSE OF THE
ANOINTING

DR. VON BRAND

HOV
PUBLISHING

Hated Because of The Anointing

HOV Publishing a division of HOV, LLC. www.hovpub.com
hopeofvision@gmail.com

Cover Design: Hope of Vision Designs
Editor/Proofread: Valorie Wright for *Genesis Literary Indulgence Editing Services*

Contact the Author, Dr. Von Brand at: vonbrand619@gmail.com

For further information regarding special discounts on bulk purchases, please visit www.hovpub.com or contact hopeofvision@gmail.com.

ISBN Paperback: 978-1-955107-69-3
ISBN eBook: 978-1-955107-68-6

10 9 8 7 6 5 4 3 2 1

Printed in the United States of America

DEDICATION

First and foremost, this book is dedicated to my God mother Verna Mae Gardner whom I love immensely for sticking with me through all of the good, the bad, and the ugly. For being a sounding board as the mothers of old would say and for always being a voice of reasoning and encouragement. For believing in me when I would question myself. For being a real mother to me after I lost my biological mother. I am blessed beyond measures that the Lord saw fit to give me YOU. I only can hope and pray that I have made you proud Verna Mae.

This book is dedicated to those of you who have been abused and misused along the way. For those who were told that nobody

would ever want or love you. For those who may have been told that you would never be anything or anybody. For those of you who were ostracized and criticized just for being you. For those who were never called out or called on. For those who were always chosen last. For those who were never good enough in the eyes of your oppressors. For those who were rejected but protected by God.

ACKNOWLEDGEMENTS

First and foremost, and 40 years later, I would like to thank God for giving me the courage to share my life with you.

I thank God for my Mother Josephine and the life that she lived before us as a Woman of God. She was not perfect, because no one is, but without the solid foundation, her strength, and boldness, that has clearly passed on to me, this story may not have ever been written, or it could have been written with a different ending.

I thank God for my Father Hosea, who showed us what a real man looks like and what is expected from one. This allowed me to hold on to the image of how hard my daddy worked, and how this was a way that he demonstrated

his love for his family. That he was not abusive towards my mother but honored her in more ways than one. I'm very thankful and will be forever grateful for my upbring in the Holiness/Pentecostal/Apostolic churches of the Living God. It forever changed my life of rebellion and helped me to endure the season of abuse that I suffered at the hands of my ex-husband. It catapulted me into surrendering my life to my Lord and Savior Jesus Christ, which is the best decision that I could have ever made. I am now the Senior Pastor of Faith Apostolic Ministries here in the state of Florida. To God be the glory! Who knew because I surely didn't.

I thank God for my bestie, Jan Jan, that is what I call her. (Janice) who God used mightily to keep me from throwing my entire life away and dropping out of high school with

only 5 months left before graduation.

I thank God for my God-mom Verna, who has encouraged me for years to write the book and who has been in my life pushing me every step of the way, and I'm forever grateful that God allowed our paths to cross.

Finally, I thank God for my current husband, Robert. My covering Dr. Lovan Sands for all her words of inspiration and encouragement. My dear friend and sister, Prophetess Shawn Quallo who really gave me the courage and inspired me to pick up the pen, and just write. I truly thank you all and I love you the most.

A special thanks to everyone that purchased and read my book. I pray that you have found hope, courage, strength, peace, love and deliverance from reading about just a

portion of my life.

May the Lord forever keep and bless you all,

In His Presence,

Senior Pastor Dr. Von Brand

CONTENTS

INTRODUCTION

If you're reading this book, I want you to know that you're better than that, and it doesn't matter if you've been told otherwise. As I have gotten closer to the Lord, I have learned that words make up stories, stories make up chapters in our lives, and chapters make up books. Get up woman of God and write the book. Some of us even have volumes that have gone untouched, but it is time to tell your story and save someone's life and destiny. My prayer today is that my story can help change your life, bring healing to a broken vessel, and wholeness to God's daughters. Now I do know that there are plenty of men out there that are caught up in domestic violence situations and may even be

stuck there and have no idea how to break away. I understand but I'm speaking to the women now. It is my calling to help broken women, and so I command today that the chains of bondage be broken off your life today daughter and that you be set free and made whole in Jesus' name! All I can say to the women right now is get out and get out NOW!

Let me start by saying that I fell in love with a demon. I dated and married him but thank God, I am still here to tell my story. Everyone has a story and this is mine. I know for a fact that some of you may have experienced the same thing. Had I known at the time, what I was falling in love with, then maybe things may have been different, but who knows? Maybe you can relate and maybe not but I hope if you have been broken or wounded

in any way you can find strength from my journey. I want you to know that someone else's deliverance will be found in your pain and even in your words. I encourage you today to tell your story. And that can only be done by you letting it be known to the public. This may not be for everyone, but it is for those who have managed to survive from everything that was thrown at them, including the kitchen sink. Let me be clear, I don't care what the story is, abuse of any kind, whether it's physical, verbal, emotional, spiritual, sexual, psychological, financial, or mental is never ok. Some of you may be wondering how in the world did you survive when you know for a fact that others did not. This is especially for those of you who do not look like what you have been through. It is dedicated to those who can testify today that I

am still here. I want to let you know that there is so much purpose on your life. Satan may have commissioned his best weapons of mass destruction to totally destroy you but it failed because God's hand is upon your life. I don't know about you but life and death stood face to face, and darkness truly tried to steal my heart away as the songwriter would say, "but God's mercy said no."

CHAPTER 1

He Tricked Me

I share my story because a lot of abused women will not. It is humiliating, demeaning, degrading, and embarrassing, but it's still my story. A headache, a heartache, abused and misused. Disrespected in every area that you could possibly imagine. Darn near raped by his friends, but God! I was introduced to drugs but took the beatings instead of the drugs. Kidnapped at gun point, thrown out of moving vehicles, because I refused to have sex and left for dead. Contracts on my head and even the heads of my children because of his misuse of drug money and let us not forget all the adultery

that had taken place during the marriage. He even fathered two more children while still married to me. As I look back over my life and ask the question, "now where do they do that?" I know that it happens to women all over the world, but why did it have to happen to me?

Afterall, I was a good girl, wholesome, a good mother, and a better wife to him than he even deserved. All I could say was Lord what in the world did I get myself into, because surely this was not the Lord's doing. This was a question that I would ask the Lord repeatedly, until he answered. I had a short-lived marriage, but now that I look back, it was not short enough. If only I would have known then what I know now, my story may have been written somewhat differently for sure, But God! It is what it is and it ain't what it ain't, but you know

what; I am still here!

I'm not angry, nor bitter. I'm no longer distraught nor devasted. I'm not even ashamed or embarrassed anymore. Confused nor dismayed, but I am grateful, thankful, blessed, freed, healed, whole, and delivered. One may ask, "how do you conclude or even incorporate being grateful, thankful, and blessed from all of the hell that he put you through?" My answer would simply be because God let me live. I survived a very traumatic situation that have left a lot of other women mentally destroyed for life. They lost themselves during their toxic relationships and was even stripped of their self-esteem, worth, value, purpose and even their dignity. They were left empty, broken, misused, and confused. They were left with nothing!! Thousands of women were not just

mentally damaged, they died in the process. I have seen some of the same women that were around me when I was going through some of this tragedy, some knew, others didn't, but if you see them today and look at me, you will think that it was them that suffered the horrendous acts of violence and not me. Some even ended up prostituting and hooked on the same drugs that my ex-husband introduced me to, and even worse than that, they died in the process of trying to make their way back through that portal. My children's lives were spared, and I'm eternally grateful for that. So, yes you see. I am blessed beyond measures, because I withstood the one thing that I hate the most and that was a test. It was all a test!

Have you ever been beaten so badly, that your own siblings that slept in the same bed

with you did not recognize you? Well, I have. Abused and misused. Ostracized and criticized. Rejected but protected, and just plain ole hated; not because of what I had done, but because of who I am. Even though at that time, I had no idea who I was, nor where God wanted to take me. I do not know who needs to hear this, but what I do know is that it needs to be heard. One thing that we as women do, and I've been guilty of doing it myself, is that we like to cover up the wound while it's still bleeding, causing us to bleed on ourselves and even others. Sometimes even leaving us to bleed completely out. And then we go right back and jump into yet another relationship with another broken man just to repeat this vicious cycle.

Let me begin this story at the age of 16, when I became very suicidal, and no one ever

knew it because I kept it secret. You see, I was dealing with low self-esteem and depression, but never really knew what it was, until years later. I knew something was there and that something was wrong but did not know exactly what it was. My dad worked all the time for the railroad as an engineer, so he was gone more than he was there, and my mother was pretty much the one that was raising us. In other words, my daddy went out to get the bacon and momma fried it up in the pan. My mother was an extraordinarily strong natured Woman of God, very firm with strict teachings, beliefs, and upbringing. This means that we were raised in a loving environment but very strict.

By the time I was almost 17 years old, I began to look at the things that some of my peers were doing and naturally I wanted to do

them too but couldn't because of my mother's faith, this became frustrating for me. I was not allowed to wear pants for years. I think that is why I love dresses so much today. I was not allowed to go to parties because they were playing secular music. Although I was a junior about to become a senior in high school, I knew that wearing make-up was out of the question, and I dared not mentioned anything about a boy, even though I really had no real interest in boys other than saying, "oh he's cute" to one of my friends as we engaged in secret laughter and a conversation piece about them. Momma said "NO WAYYY" more than she said yes, because of her Pentecostal/Apostolic beliefs, which caused me to become very rebellious. I began to literally hate going to church, but I still loved God. I did not want to be around the

saints or anything that even resembled the saints. That thought was sparked because my mother was a true giver, and my siblings and I would see a lot of them just taking advantage of her, which I know my mother knew, but she would help them anyway. This triggered so many emotions on the inside of me along with the other teenage emotions that I was already dealing with, that I just did not want to be around all the hypocrisy. Needless to say, it just left a bitter taste in my mouth. Very bitter! However, as I began to mature, I began to just talk to the Lord for myself. This was one of the things that I would always hear my mother saying to us. The one thing that I had been rebelling and fighting against, was the one thing that saved my life and even caused me to realize my purpose. The church!

I remember how my siblings and I would say these words all the time, "that when we grew up and leave momma and daddy's house, we were NEVER going to get saved." Point blank and period! I mean how do you experience church hurt before you even get in the church? Thank God for his saving grace, maturity, and His covering. I was now 17 years of age and was in my senior year in high school. I was so excited about being a senior and focused on my transition from high school to college. Or at least that's what I thought. I had no idea that there was about to be a monkey wrench thrown into the equation. Out of nowhere, one of the finest boys in the school seemed to catch my attention, or should I say, that I caught his, because again, I was very focused on college, so having a boyfriend

wasn't even on my mind. It just seemed like he was fixated with me. Almost obsessed. I served him notice fast that my daddy said that dating was off the table for me until I was finished with high school because it would only distract me. How many of you know that daddy was so right? He did not say much, but when he did speak after that I learned to really listen.

After several months of telling him to just go away and leave me alone. I noticed after a while that he just would not give up, so this intrigued me, and I began to sneak and talk to him over the phone. Afterall, I wanted to have something to remember in my teenage years other than churching all the time. I mean if the doors of the church were open, then we were open. When the saints were on their knees praying, momma would tell all 8 of us to get on

our knees and pray too. Well, this was the last thing I wanted to do. Especially as a senior in high school. We even had in-house Bible studies weekly and our house and sometimes we even had what are called "shut-ins" where you stay and pray all night. It just seemed like it was over kill 24/7 just too much for me, so a strong spirit of rebellion set in over me. Eventually, my mom got wind of it, and began to allow me to talk to him, even though my daddy was still totally against it. There is a cliché that says, "Father knows best." In this situation, he really did. I had no idea that my high school sweetheart was about to become my worst nightmare. And just like that my entire life shifted.

At one point, I really and literally thought that I was just losing my mind. I literally

thought that I was straight up tripping. That is because I would dream a lot. I never understood half of the things I had visioned and would share it with my mom, who tried her best to explain it to me, but I was just too young to really understand the logistics of it all. I didn't realize that the gift of the Prophet rested upon my life, although momma would say that to me all the time, it was still very foreign to me. In addition to that I was trying to get away from the church so the last thing that I wanted was some type of gift that would keep me connected to them. At the time, my mother was the church drummer. She kept her drum in the living room in a corner and all 8 of us knew that this was not a toy and we were not allowed to tamper with it. I remember a dream I had at 5 years old where I was beating the drums. When I woke

up and I went to share my dream with her. As I shared this dream with my mother, it caught her attention, and she stopped cooking long enough to listen to every word intently. She then told me to go into the living room and get her drum and start playing it, and when I began to tap that drum, her mouth flew opened and I heard her gasp. She began to rejoice! I had no idea why or what had just happened, but she began to say that "the Lord anointed your hands in your sleep." The next time the doors of the church were opened, which was the same night, y'all already know who had become the new drummer for the church right? Yes, me. I was so tiny, that they would prop me up on pillows just to reach the snare. That is just one of the many episodes or visions should I say that I was experiencing, and my mother would always say

that all my children are anointed, but she would also say, that Von is gifted and anointed. Did not know exactly what she meant by all the things she would say, but what I did know is that I did not want it, but I thank God that I did not have to pay a price as a young child for my lack of understanding. I know that I always seemed strange even to myself, because of the things that I would experience. I knew that I did not fit in, nor for some strange reason did I want to. I was a loner, and I liked playing and staying to myself, even though I had seven brothers and sisters.

What I did not know was that my mother's commitment to God was laying the foundation to my commitment with the Lord. I thank God for her example even if I did not like or understand it all. One Friday night, once

again, we were back in church at a revival that my Apostle was leading, and once again, church was the last place that I wanted to be. What makes this prophetic night so memorable is because, I received a prophetic word from my Apostle that was so on point, but to untrained ears, I was trying to figure out "how?" You know, the soulish realm. The prophetic word that he released to me was that he saw this tall light skinned fellow/young man tricking me. Although my mother was constantly telling me to be careful, she was not telling me "how" to be careful. Afterall, I was not sexually active nor was I thinking about changing that. So, to be on the safe side, I began to do what any other 17-year-old would do if they did not want to be deceived or end up pregnant, and that is I began to try to pull away and break up with him. I

began to put emphasis on how much I wanted to go off to college and get my education. I mean, of course I wanted to do that, but I wanted freedom from my mother too. So, college was truly my out. Do not get me wrong, I loved, loved, loved, my mother, but she was just too clingy for me, and I just could not take any more. Or at least that is what I thought.

When I tell you that it was not even a month later when the Word of the Lord had surely come to past. I mean it manifested word for word just like my Apostle had said. Not only was I in total shock I was just devastated. I was pregnant at the age of 17. I was just sick and traumatized, overwhelmed and just plain ole scared straight. I remember coming home from school one day, and my mother looked at me and she said, "Von, you're pregnant!" Of

course, I immediately began to say no ma'am, because as far as I knew, which was nothing, I was not pregnant. I had not been to a doctor, but I had noticed that my breast was very tender, and I was throwing up a lot, and just so happened that as soon as I walked in the door from school, I threw up. I mean, how could this have happened? Literally thought that I had caught some type of virus or something, but what I had caught was a baby. Because after all, He told me that he was not going to get me pregnant, and like a fool, I believed him. He told me that he loved me too much to screw up my life. But what he did not tell me was that he did not want me to leave HIM and go off to college. And like an idiot, I fell for it, because I really did love this boy. He would say to me, "if you loved me, you would let me" and I would

say to him, "if you loved me, you wouldn't ask me to do that." However, I still became vulnerable and weak. Plain ole foolish, stupid and naïve. Just like Apostle said, he tricked me.

My mother insisted that I go to the clinic, and I remember begging her not to make me go, but she began to say, you're having sex, and the Lord showed it to me. I stood in her face saying no ma'am, I'm not. Just lying! Mainly because I was a very private person, and to this day I'm still very personal but not to that degree because if I were you wouldn't be reading a book concerning pieces of my life. I felt so embarrassed for her to even think of me in that way. I began to beg her to please not make me go to the clinic, but I went anyway. I was so concerned about somebody seeing me in the clinic, that I really lost focus of why I was

going. I got my best friend Jan to go with me, and when the nurse came out and said "no, you do not have a bug or virus," which is really what I thought it was, since some of the children at school had been sick, "but you my dear are pregnant." My heart sank. OMG, what was I going to do, and how was I going to tell this to my daddy? Everything that he had said to me concerning this boy, had manifested. I was crying so hard that the nurse offered to take me home, and maybe she could tell my daddy, because I was clearly in no condition to drive like that, and my bestie had not begun to drive yet.

I remember her asking me, "what was I going to do?" I just told her I was going to lie to her and tell her that I was not, but my mother was not buying it at all. She was no fool and she

knew that I was pregnant. Plus, I had always practiced telling her the truth, that I was not even sure that I knew how to lie to her the right way, if that makes any sense to you at all. I felt so bad trying to lie to her, that I just finally admitted it.

CHAPTER 2

The Change

When I see "Lifetime" movies that say, "Pregnant at 17" or anything even closely related, I tune in, because that was once me. Although I really wanted to drop out of school just 5 months away from graduation because of fear of what people might say, and how I would not be able lift my head walking amongst my peers with a big belly? Thank God for Jan encouraging me not to drop out of school, because I was so serious about quitting, and what it would do to my image, because after all, I was looked at as one of the smart girls in school, and not a wild and loose cannon, just

waiting to be fired. Needless to say, I graduated with honors, made the National Honor Society, and was in the top 10 percentile out of one of the largest classes that had ever graduated from Charles B. Glenn High School. I owe that to God for using my bestie Jan to tell me how much my mom was going to kill me if I dropped out. Besides, where was I going to go, because I knew that she was not going to allow me to stay at home. My mother was very adamant about education. I even managed to hide the pregnancy without people knowing because I never really began to show until 3 weeks into the month of May. Graduation was June 2nd, and I was due to give birth in September, so it just seemed to somehow work out. I was so angry with God for always having us in church and missing out on what I thought were the fun

things in life as a teenager. After turning my back on God to some degree I was thinking that maybe just maybe He was still answering my prayers. I just thought that if any of them knew it would be too unbearable for me to handle. It was my secret and I just didn't want it to be known by anyone.

I know as women, we go through a phase that is known as, "The Change" in our lives. Well, I would have you to know that as soon as I told my then boyfriend that I was pregnant, I went through "The Change." He immediately turned into someone that I had not known before. Yes, he went through the pregnancy with me, but he had no sense of responsibility, nor did he want any. I mean, yes, he went to a few appointments with me, but that was pretty much it. He kept telling me that his momma

was going to help us with this baby, and my question was, "how will your momma be able to help us when she has 5 children of her own, and you guys are living in government projects, which tells me that she needs help?" I do not know why, but I just expected for him to be just as responsible about this thing as I had been and was trying to be. I just wanted him to grow up like I literally had to do over night, because at the end of the day, this baby was not his mother's responsibility, but ours. We did this together, and I was definitely going to keep my baby and she was coming, like it or not. Nine months later, I gave birth to a beautiful bouncing baby girl, all praises be to God, but trust me, before she got here, I had already gone through so much trauma because of him, that I

still cannot believe to this day that years later, I had said yes to his proposal of marriage.

I do not know if it was because he had gone off to the military, and some time had gone by or if it was just because that almost 5 years later, I was pregnant again, and just did not want to live with the persecution and the guilt and shame of having done this to myself again, but I had. Yes, I was a little older, but I knew when he was proposing that he was not ready, nor was I ready to marry him. After all, I was in college, working a little job at the deli, still at home with my parents, and was doing good with the new challenges if I must say so myself, and I will say so. Even my parents were quite impressed at how well I was handling parenthood as a single parent and so was I. With all of that, I knew that I truly did love him and

accepted his proposal, but what I did not know was that I had fallen in love with a bipolar demon and my life was about to take yet another turn in the wrong direction.

CHAPTER 3

All Hell Breaks Lose

Saying yes to my ex-husband opened all kind of doors that I only wished that I could have kept closed. When I tell you that if it had not been for the Lord who was on my side, I have no idea where I would be. All hell begin to break lose in my life not even 3 months into the new marriage. I thought maybe that I could talk to his mother about his behavior in hopes that she would give me some good sound advice, but all she said to me was "well I guess the honeymoon is over" which was another blow to me. Words that I will never forget, yet I have truly forgiven her. God knows it was

because I was not about to let my parents know the monster that he had turned into in such a short period of time. Especially since they, particularly my father had warned me about him. I remember one day shortly after we had gotten married and we were just lying on the floor watching TV, and the next thing I know, he hauled off and kicked me in my stomach repeatedly for no reason. I began to curl up in a fetal position to protect my baby because I was between 8 and 9 months pregnant, and I began to ask the Lord to make him stop. I remember screaming out and begging for him to stop, telling him that he was going to kill the baby that was due any day now and he just suddenly stopped. There was such a rage of anger that had come over him and I had no idea at the time that he was bipolar, and even though I was the

one that was being physically abuse, for some strange reason I just began to feel sorry for him. I know right? Makes no sense at all. Afterall, I am the one laying on the floor bruised all up and in pain. For obvious reasons, I couldn't fight him back, because I did not want to miscarry or hurt our son. After him begging me not to leave him and him apologizing and swearing that he would never do it again, and telling me how much he loved me, and how sorry he was, hugging me after he stomped me and our unborn baby the way that he did, like an idiot I believed it. I forgave him and stayed with him anyway. One thing that I will tell a woman quickly in this day and time, is don't walk, but RUN and don't even think about looking back. That does not express love. That is hate and sometimes even self-hate. Don't wait around

for him to hit you again because you just may not make it out.

He began to display the true definition of the word bipolar. I felt so trapped, because while dating him, he began to pull me away from the few friends that I did have, remember that I was pretty much a loner. So that caused me to feel like I could not share my pain with them, and I was not about to tell my parents, especially my mom, because believe me, my mother could go from zero to one hundred just like that when it involved her children, and she did not care how old you were. She would have literally shot him, and I knew that she would have, so I kept it from her and once again lied when she asked me if he was hitting me? I honestly believe that she always expected it, but because I never agreed or confessed it to her

that he was, that she would kind of back off. However, she would always tell him that the day that she found out that he was hitting her daughter, that it just may be his last day here on earth and that it was going to take 3 men, 5 women, and 4 children to pull her off him, and I knew that she meant it. My mother was from the motor city of Detroit, and she passionately believed in fighting if she had to and cutting or shooting was definitely no exception to the rule. Especially if it concerned her children. I thank God for the friends that were determined not to allow him or his behavior to intimidate them like it had me. Afterall, I was not accustomed to this type of behavior, so yes, at the time it was a little intimidating, but PLEASE do not try that on me now, because I have truly turned into my mother. Do not come for me unless I have

called for you, and that is something that I have not done.

I remember having to walk almost like tippy toe style in the house because I never knew what would trigger his mood swings. Even the baby crying would cause him to become explosive. I wanted so badly to leave but I did not know how to get away from him, because he would always tell me that if I ever tried to leave that he would kill me and our 2 children, and because of somethings that I had witnessed him do with my own eyes, I believed him. I literally became enslaved to the same man that once expressed his dying love for me. Yeah right! I did not know a lot about the "streets", but what I did know based on what I had been exposed to growing up is that this was

not love at all. It was a spirit of control, and he took total advantage of it.

This man literally had me wondering what I could have done so wrong, that caused him to respond to me in such an abusive way. How could everything go from being so good to so wrong in less than 3 short months. The truth of the matter is, that it was never good, I just wanted to believe that it was, so I accepted it. Am I saying what you think I'm saying? Yes, it had been there all the time. I just didn't want to see it. So that saying that love is blind, I can confirm that it really is. I just refused to see it or listen to my friends or family about it. In addition to that, he was very lazy, and did not even want to work on nobody's job to help take care of the 2 children that he fathered. He had no problem dropping me off to work, he just did

not want to go to work himself. Whenever I was feeling strong and brave, I would ask him if he had found work that day or how many applications, he filled out knowing later there would be a price for me to pay just for asking.

I cannot even begin to tell you how many people would tell me that they had seen him riding around town with other women in "MY" car. I entered the marriage with that car. therefore, it was "MY" car. And I did not want to hear nothing about community property. At the tender age of 22, all hell broke lose in my life and I could not understand why or what had I done to deserve this type of hell. All I do know is that it pushed me into a life of prayer. I was now starting to understand what all the churching was about when I was at home under my parents' roof. The church began to become

my safe place, and though at times he would take me per my request, he absolutely hated it, because he noticed that the more, I attended church, the stronger I was becoming in every area of my life. I can't help but to think about the scripture in the book of (Exodus 1:12), which says the more they were oppressed, the more they multiplied and grew. I was beginning to get so strong spiritually, that I had no problem telling him the things that I would see in the spirit realm concerning him. I even told him one day that if he didn't stop threatening to blow my brains out, the Lord said this would be the way that he would leave out of here. I'm not boasting or bragging in any way at all because no matter what happened between us he was still the father of my children. Unfortunately, that was the way he passed away; at the hands

of his then estranged wife. Yes, I was *Hated Because of The Anointing.*

CHAPTER 4

I Am Sorry Is Not Enough Anymore

I cannot even begin to tell you how many fights we had and how many times I was hit in my face. Not with just an open hand, but with his fist. How many times he would tell me that I was ugly, and that nobody else would ever want me especially with 2 children. That I would never be nothing, nor would I ever do anything with my life. I mean, any and everything that this man could say to me to tear me down, he would do it. Keep in mind that I was only 105 pounds, 5 feet 2 inches, and knew absolutely nothing about fighting, because we were not allowed to do that in our home

growing up. But trust me, I learned very fast because although I didn't know anything about fighting, he forced me to learn fast. Otherwise, I would have been getting beat up every other day. Although I hate that it had to take this route, I learned very quickly that I truly had my mother's spirit to fight back, and to do it fast. All of this was causing me not to be fearful, but fearless, and he knew it. He was losing control and he knew it.

I must say that except for during the time that I was pregnant, something would always rise in me to fight him back, and you best believe I did. I did not care what the consequences were, but what I did know is that if you were big enough to give a lick you were big enough to catch one. Looking back over it now, I guess it's safe to say that I truly had my

mother's spirit of boldness in me, but just did not know it at the time. We would fight so much, that when he would come in the house, I would just begin to ask him, "what time are we fighting?" Let us just go ahead and get it over with so that I can get some sleep tonight. Afterall, somebody got to pay the bills up in here.

It came to a point and time when I began to realize that this was not about what I did wrong, but this was about how he felt about himself. I finally began to realize that it was something to this "praying" thing that my mother would always talk about, and even demonstrate to us when we were children. His drug use had spiraled so out of control, that we were now having our door kicked in and people were burglarizing our apartment. Contracts and

Hits were even being put out on my life and the lives of our 2 children because of the mishandling of drug money. I promise you, that you cannot make this stuff up. And what made it even worse is that he never even seemed to have any money and he would very seldom contribute anything to the household to take care of the expenses, although he was dealing drugs. Even when he would get little odd jobs here and there, in my opinion he may as well not have been working because again, I truly saw little of it.

Things were getting so bad, that I was even uncomfortable just going to the corner store for fear that somebody was going to shoot me or my children, because of his lifestyle. The things that he was doing out in those streets. I remember how my mother would line us all up

at the door before we went off to school and she would anoint our heads with oil and pray over us, and even my friends if they stopped by the house to walk with us. Sometimes she would even put some in our shoes, and I am so glad that she did, because it seemed like those were the days that there would be some type of fight going on at the school with gangs and we would find ourselves running for our lives. There were many days I would find myself doing the things I saw my mother doing to us like praying intensely over us. I would pray over my children and it didn't matter if it were just to go outside and play, if it was taking them to daycare, or even if it were just to the grocery store. Afterall, wherever I went other than to work he was sure to go or to take me and that included taking me to my parents' house. His

controlling ways became so abusive and he was even telling me what I could and could not wear, how to wear my hair, and who I could befriend, as if I needed him choosing my friends. I was not allowed to speak to someone of the opposite sex, because of jealousy and his own insecurities. Yes, you heard me right. If a guy even spoke to me in passing, I had to be in relations with him, which was the farthest thing from the truth. Oh, it was horrendous and a life full of hell! Again, I would find myself praying and asking the Lord, "what have I gotten myself into?" and I was so sorry that I did not listen to my parents. I was praying so much, that I began to ask him to take me to church. The relationship had gotten so bad, that I was now asking to drive my own car, that I was paying the note on, just to keep the peace, because I

knew that it was going to spark a fight between us. That way I would not have to risk him accusing me again of cheating on him, when in fact, it was him that stepped outside the marital laws, and never ever was it me. Not even one time.

This unacceptable behavior went on for years, but I did not want to leave him. Just stuck on stupid, I guess. And more than anything, I wanted to believe so badly that he did love me and that he really was going to change, but that never happened. I did not want to go back home, because even though it was straight up hell, and a form of bondage for sure, I just did not want to go back home to my mother's house. Pride was in my way. There was even a situation where he had come in from "looking for a job" according to him but the clothes he

had on said otherwise, and when I questioned him about his attire, shorts, and a t-shirt, he hocked up phlegm from his throat and proceeded to spit on me, which is one of the most disgusting forms of disrespect there is. Clearly, I was getting stronger, because that day, I also hocked up phlegm from my throat and gave it right back to him. He was in total shock. I mean real disbelief. I think it was at that point that he realized that she is not afraid of me anymore. You do not know how right he was. The fear was gone. Now do not get me wrong, of course, we fought, but he realized that he was losing his grip of control off my life. He began to say things like, "what's wrong with you or so you think you're me now? So, you think you're gonna whip my ass?" His words, not mine. And me just being me, I responded by saying; that

even if I don't, you will know that I done been there, and proceeded swinging with everything that I had and throwing whatever my eyes could see. For the first time ever, I could see real fear in his eyes. We even ran into one of his buddies the next day after one of our fights, and I remember him asking my ex, "did you even get a lick in?" "She done whipped your ass. She busted you up pretty bad man" as he snickered underneath his breath. This embarrassed the stew out of him, and I could see it. He was now starting to feel what I had been feeling for years. It was not a good feeling, but he knew that I meant business, and he knew that he was gonna have to find him a new rookie to furnish his lifestyle. And I didn't care who he had found, though it should have been Jesus, I'm just glad

that it wasn't me He knew that this toxic marriage was over.

CHAPTER 5

No More!

I never wanted to divorce my ex-husband because I really loved him, but unfortunately that love was not reciprocated. And even more than that, it made me question how much I had truly loved myself to subject myself to such abuse. I honestly believed he wanted to love me, but he just did not know how. He clearly had issues that I could not help him with, because I could barely help myself. I would always ask him, "why are you so angry?" Of course, he never had an answer. It was not until after we divorced that I knew the source of his anger, and it had absolutely nothing to do with me. I was also informed that this was the kind

of behavior that he had witnessed his father doing to his mother while growing up and he liked the sense of power that it gave him.

Although I had made my decision to stay in the marriage, since I had made my bed and I was going to lay in it, there was one day when I just made up my mind that I didn't have to lay in that bed anymore. Enough was truly enough. Of course, there was yet another fight involved, and my baby girl ran up to him, as if though she was trying to defend me, and I will never forget the look of rage on his face. He had me by the throat with one hand, and he picked her up with his other hand and he just threw her into a wall. A brick wall at that. That was it for me. I clearly, was not strong enough to get out of this foolishness when there was fighting going on between him and me, I absolutely refused to

allow our children to grow up thinking that this type of environment was acceptable and that this type of behavior was what my daughter was to accept from a man. I especially did not want my son to think that it was ok to disrespect women like this even if he did see me subjecting myself to that type of vicious behavior. My 5-year-old daughter had given me the strength that I needed to leave. Talking about having a renewed mind, my mind shifted that day. Of course, the church got blamed for this new attitude of mine. He then expressed how much he hated the church, and that he also hated me. I didn't find out for years later that he was an atheist.

Enough was enough! Yes, the abuse and violation should not have happened, but I did not have the courage, strength, or the know how

to do it and keep my babies safe. Especially since he would always threaten to kill us all, and because of the type of man that he was, I knew that he would have done it. Even when he was putting loaded guns in my mouth and up to my head and pulling the trigger, and God would even cause the gun to jam on him when he would pull back on the hammer. Or when I was being thrown out of moving vehicles and left for dead when he became angry about something, and even when he had messed up drug money. Mind you, he would always tell me that he was not getting high, but I knew better than that, because I would find the "TOP" wrapping paper in his pants and the little baggies when I would wash his clothes. I think that there would be times when he was just too high to even clear things out of his pockets

before putting them in the laundry. I should have left then, but the spirit of fear would grip me and more than anything, I just did not know how. I knew what type of people that he was connected to and none of them looked like church people or the type of people that I was accustomed to seeing. Do not judge me! It is easy for people to say what they would do if it were them, and when it is not their heart or life that is involved. And then too, maybe they would have done something different from what I did, but remember, I was 22 years old with no "street" sense or background at all. Smart as a whip in book sense, but lacked in having common sense with boys, let alone a man, and I grew up with 5 brothers. Mind you, my 5 brothers grew up the same way I did, and that was in the church house. To my own

defense, not that I need any, because I did nothing wrong, none of my brothers acted like this. Nor had I ever seen this type of behavior with my dad. My mother ran a very tight ship, and behavior of this kind would have never survived under my mother's hand. That stubborn spirit of pride that refused to let me humble myself and just go back home to my parents, almost cost me my life.

At the same time, I was a young mother and wife that wanted her marriage to work. Not like this of course but somehow, I just wanted him to change and be the person that I fell in love with. Looking back over my life, I now realize that this was the person that I fell in love with. He had just managed to keep it hidden from me. Yes, yawl I had children with, loved, and married a demon. I mean his face would

literally transform right before my very eyes. Not everybody will admit this, but I will, because maybe, just maybe it will help some other young girl, or even not so young to get out and run for her life and to have the courage I did not have at the time. And Since the Lord saw fit to let me live to be an advocate and a voice against domestic violence, I'm going to do all that I can to help other women, even if it means just telling my story. I literally know some women that were in domestic violent situations that did not make it out. They literally died at the hands of their abuser. I am truly and extremely fortunate and blessed today to be amongst the land of the living and not the dead, and I do not take that for granted.

While sitting on the porch one day crying and praying, because we had had yet another

very violent and vicious fight, I heard a voice say to me, "Von, just leave. I will be with you, and I will give the strength and courage that you need to get out." The next day when he left for work, I left for good. To my surprise, the Lord was so merciful, that he even allowed one of his friends to pick him up because it just seemed like he always had the car. I didn't know it then, but the Lord was moving on my behalf. All he wanted to know was did I trust him, and I absolutely did. I had truly had enough. I grabbed a garbage bag and filled it up with whatever I could get in it. Grabbed my son's milk, and their diaper bags, threw them in the back seat of a Chevrolet Camaro hatchback, and never looked back. Nervous and all, in fear that he would come back and catch me trying to leave, but I did it. I left an apartment full of

furniture, but I didn't care about any of that stuff. I just wanted out and I wanted to live. My mind was made up. I would start over. Nothing was worth my life anymore, and especially him. It is like I had experienced an epiphany.

That strong spirit of pride had broken off of me. It was as if I was starting to really love and value myself enough to not ever allow this to happen to me again, and believe you me, it hasn't, nor will it ever. All this time I had been asking, "where is God?" This day he showed up, but I didn't realize he was there all the time. He was right there in the fight with me. I mean, who could fight like that and still get up with a bounce back anointing and carry on like nothing ever happened if God was not there with me? Not only did he fix the fight, but he

set it up to empower me, to help to empower others.

As if that were not enough to show me that enough really was enough. I remember that season in my life like it was yesterday and I'm so glad that seasons change and that trouble don't last always. I pulled up to my parent's house, broken, bruised, wounded, and almost left for dead. I knocked on the door, because I no longer had a key since I had moved out, and I could hear my mother in the background telling somebody to get the door. My baby sister came to the door and my mother was asking her, "who was at the door?" When my baby sister said that she didn't know who it was, this was yet another wake- up call for me. I had been beaten beyond recognition, so much so that the same sister that I once shared a room

with did not even recognize me. I really do not know how I even got to the house, but I do remember praying all the way because my eyes were both closed. I literally had to say Trina, it is me, Von. I was so hurt that she did not know who I was, but when my mother came to the door, she said, "Lord, that's my child! Come on in." I then said, "momma, I want to come home." She was really mad that I was looking like that, but I remember that she just hugged and hugged me. I literally felt like the prodigal son because she kept saying, Lord, my child is home. And the entire time, all I was thinking was, you mean to tell me that it was just this easy? Rejoicing in my heart and just telling the Lord thank you Jesus, I'm finally home and safe.

Her next words were, load up and bring me my keys. I saw her put her gun in her purse, and I was so scared, but I didn't interfere, because my mother was saved, but when it came to her children, she was a real nut case. A straight up Gangsta. Point blank and period! The last thing I needed to go along with two swollen eyes, and busted lips was a bullet in me, because she was in a rage. One of my brothers even grabbed the shot gun. I was so nervous, because I did not want her to kill him even though he almost killed me on several occasions nor did I want my mother to end up in prison, so I did what she had always taught us to do, and I just prayed.

I prayed that she would not find him, and if she did, that she would not kill him. I prayed that my brother would not get himself in trouble

because of my situation. I prayed that the Lord would speak to my mom as she rushed off to kill him, because that is what she said that she was going to do. Oh, I prayed that day, and it was like I was in Vegas just racking up "the Benjamins." Or it was as if the windows of heaven had opened up that day and God granted my every request. I remember saying to God that if you just get me out of this situation that I should have never gotten myself into Lord, I will serve you and only you the rest of my life. If you allow my children's father to live, even though he tried to kill me, that would be a bonus. Please do not allow my momma to find him, because I know that this would be the only way that he would survive.

Two hours later when she came back in the door looking defeated, a look that I was not

accustomed to seeing on her, she said, "I know that you must have been praying, because I could not find him, but he knows I am looking for him. I left word everywhere including the drug houses." I knew she meant business. My mother was so BOLD and NEVER showed any sign of fear so much so, that the drug lord tried to recruit her into the drug world, but she told him about Jesus, gave him some tracks that she would pass out all the time, and even invited him to go to church with us. I mean who does that? My mother was FEARLESS! Saved, but a low-key gangsta. In a lot of ways, I have taken on her spirit. I think that her boldness is one of them. Not 100% there, but not a lot intimidates me at this point in my life, and only a true and living God could have done this thing in me.

May he forever be glorified! Hallelujah! Hallelujah!

CHAPTER 6

Love Is Not Enough

Sometimes, we can love people so much that we fail to realize that the love we have for them just isn't enough anymore. We must realize that everybody is not our assignment, just like every relationship that we sometimes get "ourselves" into is not ordained by God. *How can two walk together except they agree?* (Amos 3:3). The answer to that is, they cannot. The human side of us will often try to take people with us that the Lord never intended to go with us. I honestly believe that it was in God's plan for our paths to cross when it comes to my ex-husband. The reason being is that we,

especially my mother, had an opportunity to introduce him to Christ. From what I understood, his father was an atheist, and this is what he was trying to instill in his children. As to whether he accepted Christ or not, that was on him, but I pray that he did. I never hated or disliked him, even though I had every reason to do so. I just could not do it. I was just so grateful that the Lord allowed him to release me so that I could be free of him. He just had this look on his face like he was so confused, but I know now that it was the Lord's doing. That he was confusing the mind of the enemy long enough to get me out of bondage.

Another strange thing about that is, that he would always say to me that I deserved better than him, because he wasn't S#!t, but that he was not willing to let me go. You might be

asking yourself, why is Von sharing this with me and my answer is, because as women we sometimes choose to hear only what we want, when all the warning signs are staring us right in the face. Please pay attention to the warning signs. Love yourself enough to leave when it doesn't look right, act right, or even smell right. Don't be me. I am convinced that the Lord graced me for that assignment. That may not be the case for you. And from that day until the time that he left this world, I never treated him the way that he did me, nor belittled him in front of his children. As angry as I was at myself for staying in it as long as I did, I never told them anything bad concerning their daddy while they were growing up. It was only until they became adults that I uncovered or unleashed the devastating truth as to who and what their father

was. And that was only because they wanted me to tell them more about their daddy.

I was always up front and honest with them, for one because I'm trying to live a life that's pleasing to the Lord, and secondly, because they deserve to know. And even with that, I continued to tell them that he is still your father, respect him, though he never respected me in that manner. I Never quite understood why I wanted them to respect someone that did not respect me until I grew in Christ and realized that it was Biblical principles.

My ex-husband was the vehicle that was used to father my children, and I am eternally thankful for that. No matter how ugly it was, God will still get the glory out of my life concerning it. What I am most thankful for is the fact that because of his abusive ways and

dishonor towards me, it pushed me to a place of prayer and salvation and caused me to run back towards the thing that I was trying to run away from, which was the Church. I mean, how can I be mad about that? I would be lying if I told you that I was never scared, because there were times that I was, but I never allowed him to see my fear.

I would stand toe to toe with him, and we would fight like we were strangers in the street. I am not talking about arguing. I am talking about throwing punches. Real fist blows because I understood the assignment. It was his life or mine. In addition to that, he wanted me to be afraid of him soooooo bad, but I never could fear him in that way. Yes, I feared the situation because there were children involved and clearly, I was more concerned about their

safety than mine, but that all changed the day that he threw my daughter into a brick wall. I can still see the image of her little head bobbing back and forth like a little wet dish rag if that makes any sense to you. It was his way of trying to control me. That was a BIG mistake, and I know that it didn't take a long period of time for him to figure that out.

I never wanted to do this, but I was not about to just sit there and allow him to hit me and there be no repercussions. I just wasn't cut-out for all of that. After all, I am my mother's daughter. I never wanted this lifestyle, but I learned to adjust to it very quickly. You give a lick, you get a lick, I remember several times when he would tell me to just stay down, and I would get up and say, "NO" you wanted to fight, so let's fight. He could not believe the

courage that I had, and neither could I even though there were so many times that I thought I had none.

He once said to me "my mom let my daddy beat her, so why can't you just stay down?" Wait! What? Are you kidding me right now? I responded by telling him because I'm not your momma, neither are you my daddy, so let us do this. And we began fighting again. I had gotten so good at it, that I must admit I would sometimes go so far as to instigate a fight. This was just to let him know I was not afraid of him or his wolf tickets and what once was will never be again. Just thought that I'd close the back door for you.

I think the fear that I had was coming more from him raising his voice at me, because it was so heavy. And my daddy never raised his

voice at me because he never had to. I just was not accustomed to the raising of the voice thing, so it was kind of intimidating. And to this very day, though God has healed me and made me whole in that area, if someone raises their voice at me, it takes me back to that time and that moment in my life, and I am ready to fight. Now yawl pray for me right there and do not go no further. Yes, I'm delivered, but I didn't forget. It causes me to go into defense mode.

It took years before I could trust again, just like it took years before the healing and deliverance manifested in my life. When I tell you that every way that this man could tear me down, he did. He physically, emotionally, spiritually, mentally, and verbally tore me down. He would constantly tell me that I was ugly, and because I was already struggling in

that area, not knowing my worth, I believed it. I never really thought that about myself, but he just had a way of making me believe that I was. Plus, there was nobody in my ear to tell me otherwise, and it seemed that no matter what my momma or my daddy had told me up to this point, carried no weight. I do not believe that now, but back then, you must remember that we met in high school at the age of 16, so I was already on this roller coaster of struggling with my adolescence, so I was left open and very vulnerable. Trust me, that's not my story today.

By the time I discovered who I was and my worth, the value had gone up. That's because I learned to love me. That's the only way that you can really allow someone else to love you, and you are able to reciprocate the love, is that you must first be in love with

yourself. I would even ask him "if I'm so ugly, why did you look at me? Something must have caught your attention. Not only did I catch your attention, but you gave me two children and you married me."

I know now that I was never ugly, but that he was just throwing out whatever he could to kill my self-esteem, because his was so low, and to keep me in that life of bondage. Physically, he was a very nice-looking man. He was easy on the eyes if I may say so myself but, on the inside, he was a very broken young man. Let me just tell you, jealousy was not his strong suit. He didn't want anybody looking at me, nor was I allowed to look at anybody, without it being a fight. I literally had to walk with my head down to keep from being hit in public,

because he spared no mercy. This was also being done to instill fear in me.

To be honest, it was as if though I was his dog, and he was trying to retrain me from the previous owners. Or like I was his prostitute, though I wasn't turning no tricks, and he was my pimp. Again, he wanted something that he wasn't willing to give, which was respect. People would tell me all the time that I was pretty, but at the time, I struggled to believe that I was. I think that one of the reasons was because in his family, pretty was defined by the complexion of your skin, and not by your physical attributes. In short, if you were fair or light skinned, you were automatically "pretty "and anything beyond that was considered ugly. It no longer seemed to matter what my parents instilled in me or what other people told me.

I wanted and needed affirmation from him, and he knew it and that would only happen during sex (it's ok to say that women) because good or bad, we were legally married. Either way, no real woman wants to hear how beautiful she is ONLY during intimacy. It sends a sign of false information, and it has a way of still making you feel as if you're not good enough, when indeed you are.

Praying kept me sane. I could tell that the Lord was giving me strength that I didn't even know that I had. I had begun looking in the mirror and telling myself that I was pretty. That I was somebody. That I was fearfully and wonderfully made. That I was the head and not the tail above only, and not beneath. That I was better than this. That my life was valuable. That I was enough. And not only was I enough, but

that I was GOOD enough. That I was loved, even if it were not by the one person that I wanted to be loved by the most. That I did matter. I began to realize that everything that he told me that I was not, was everything that I was. I was not afraid of my possible successes, but he was. As fine as he was, he was so insecure, and was trying to pull me into the same pit that he was in. I had no earthly idea the path that my life would take, but I am so glad that I had a praying mother that never gave up on me, and that before God called her home, she was able to see me on a road to success. The fear of the unknown that once tormented me for 7 years was no more, glory be to God!

CHAPTER 7

The Grand Finale/

Divorce Papers Are Served

Nobody wants to go through hell on earth, and if they do, something is terribly wrong with them. I have so many things to be thankful for, but most of all I am eternally grateful that out of all the near-death experiences I had. God did not let me die in my sinful mess during my period in Egypt, because in hell, I would have lifted my eyes. I had no mindset to live Holy, so if this situation had to happen to steer me in the right direction so that I would be grounded and rooted in him, then so be it. To God be all the glory.

I never thought that the one person that I was only trying to love would have taken me through all of this "unnecessary" hell, but maybe it was necessary. Maybe I had to go through it just so that I can help snatch others out of it, because we must remember nothing can happen unless God allows it. I now know that delivering and rescuing other women that are in abusive relationships like I was once in is a part of my assignment. No, I am not saying that God agreed with him smacking me around or putting his hands on me in any way that would cause harm to me, because abuse of any kind is "NEVER" okay. However, what I am saying is no test, no testimony. No, I don't have all the answers. But what I do know is that I would never be able to help strengthen, encourage, or motivate others to the extremity

that I do and have done if I had not suffered at the hand of my abuser the way that I did. I love what I do, which is helping the daughters of Zion. So, when I say that I understand, and can back it up with evidence, I truly do understand. Sometimes, people just need someone to help push them over the line. So today, even though I've never done drugs, I'm gonna be your pusher, because I may have what you need. I'm gonna be your drug dealer today because your deliverance could not only be in my story, but it must be the very words spoken from my mouth.

I've spent many days and nights asking the Lord to give me the strength and the courage that I needed to leave this man. And I'll never forget the day that I heard the spirit of the Lord say, "Von, you've already left." That was the

release that I needed to file those papers. After I came back from the attorney's office, I felt so liberated. Like I could finally exhale and breathe. I did not have to check in with anyone just to go to the store or to talk on the phone to a friend or to wear a certain skirt or dress. Yes, I could taste the freedom and it taste better than good to me. But the day that the actual divorce came in the mail, I felt like Dr. Martin Luther King when he said, "Free at last, free at last, thank God almighty I am free at last!"

As a matter of fact, I went to church that same night, and was so glad that I was in the house of the Lord. I kept my promise to God, and before long, I realized that I was now doing with my children the same thing that my mother once did with all of us, which was every time that the church door opened, I thought that I

was supposed to be up in there. This had now become my life, and I was not mad about it at all. It took some time, but I truly had forgiven him for all the damaging words that he had said to me. For kicking me in my face. For spitting on me like I was a dog without a tail. Which was the ultimate sign of disrespect. For throwing me out of moving cars and leaving me for dead. For allowing contracts to be put on not just my head, but the heads of his children. For locking me in the house at times and daring me to come out, as if though I was in a state penitentiary. For all the times that he would just choke me for no reason. For sleeping with my so-called friend. For having children with another woman, while being married to me.

I even think that he actually set me up one time to be raped, but I had no evidence. But

God! I was able to forgive him for not loving me the way that I had once loved him. For not being responsible and taking care of his children, and for causing me to struggle the way that I did with them, because he was too trifling to provide for them. For just not being there, which cost him nothing but his time, and even wanting me to abort them. I think that had a lot to do with his hostility towards me as well, because I refused to abort our children. When I would make comments like; "the baby needs pampers or milk," he would say things like; "I told you I didn't want any children right now" (knowing he was not doing anything to prevent having anymore and would get mad with me if I suggested using any form of birth control) especially condoms. He would say, "you decided to keep them, so you take care of

them." This would burn me up, but I would do just that. I took real good care of my children.

I am telling you the list can go on and on, and on. When it was good, it was good and that was rare, but when it was bad, it was beyond bad. It was hell right here on earth. The crazy thing about all of this is, that I was able to truly forgive him. It was almost like I was saying thank you for just letting me go, but I was able to do it. For one, I realized that if I did not, then my heavenly Father would not forgive me, and secondly, if I did not, then he would still have what I fought so hard NOT to give him, which was a form of control over me and I was not about to allow that to happen to me again, NEVER from no man and not from a woman either. I do not because I do not discriminate and I don't mean in a sexual relationship,

because there are other ways that women can try to control you.

CHAPTER 8

Conclusion: I Cried To The Lord
And He Delivered Me

We all have a story to tell, and this is just a part of mine. Yours may result in homelessness, rape, homosexuality, lesbianism, sexual addictions, drugs and alcohol, gang banging, imprisonment, the spirit of perversion, entertaining witchcraft, and the list goes on and on and on. But again, this is my story. It was so rewarding to me years later, as we both had moved on with our lives and had remarried, to receive a phone call from his mother one Sunday after church asking if I would PLEAASSSEEE come. I had no idea what she was talking about at the time, but I found out

later that he was in University Hospital, as he thought that he was on his death bed, suffering from a gunshot wound from his then ex-wife.

It's not that I rejoiced in his tragedy, because I did not, but just the fact that he wanted to get things right with me and his children, not knowing if he would live or die. I knew that TRUE FORGIVENESS was there when I was able to gladly take them without hesitation. When we walked in his room, his face lit up like he had just gotten his favorite toy at Christmas time or if he had won the lottery or something. He then said, "out of all the times that I have threaten to blow your brains out I cannot believe that you came. Out of all the times I mistreated you for no reason Von if you had not come, I would not blame you. Most women would not have come, had they gone

through the things that I've put you through." I then said, "of course I would come and bring your children to see you." The tears began to fall down his cheeks as he began to apologize and beg for my forgiveness. I then let him know that I had forgiven him years ago, because I needed that closure in my own life. I needed to have a healthy life for me and our children. We did not stay long, maybe about 30-45 minutes, but as we were leaving out, he left these words with me, "if anybody should have shot me, it should have been you. You are a strong woman Von to have put up with all the hell and BS I put you through and I am so sorry that I didn't treat you right. The truth is that I wasn't good enough for you, and that you were more than what I ever deserved. You were a good wife, and an even better mother. I didn't want to grow

up and become responsible, but I forced you to do it all by yourself, and again, I'm truly sorry. Thank you for coming so that I can fix it just in case I do not make it." I prayed for him, smiled at him, and gave him the plan of salvation, and went home to my husband.

FINAL THOUGHTS

I was glad when they said unto me, let us go into the house of the Lord. (Psalm 122). I pray that you will become all that the Lord has called you to be. I believe that by faith and according to the Word of God, that you have already won this thing, because you are more than a conqueror through Christ Jesus. God is faithful, and he can do anything but fail. It may not have seemed that my prayers were being heard, but of course we know that he was there all the time. I cried unto the Lord, and he delivered me, and I am so glad about it. Never allow anyone to determine who you are, what your day will be like, nor what your future

holds. You are the determining factor of that. You win! Glory be to God! You Win!

I did not have access to any of this information during my period of abuse and was blessed enough to find safety in Jesus. I am not saying that it was not out there, but what I am saying is that I did not know how to gain access to it. Anytime that you can stand face to face with your abuser and have nothing but compassion in your heart, you truly do have the heart of God in your life. My ex-husband survived that gunshot wound but died a couple of years later from yet another gunshot injury from that same wife, who murdered him in his sleep. She was sentenced to 25 years, and to my knowledge, has served those years, and has been released into what inmates call the free world. In case you are wondering how I came

up with thinking that behind all this hell, how could I say that God deserves it all, is because he does. I survived it all! So yes, God gets all the glory out of my life. That could have easily been me that was shot and killed, because remember, God knows that he tried, but mercy said no! Thank you, Jesus, Mercy said no!

Last but surely not least, I shared just a portion of my life with you to give you hope and to let you know that no matter what you're going through in your life, that there is hope. That this too shall pass. The older generation would say it like this: "once ain't forever, and twice ain't always." Yes, it's a little country, but so am I and that's exactly how they would say it. Again, meaning that it will pass, but you have got to believe that it will. David said it like this, *I sought the Lord, and he answered and*

delivered me from all my fears. You can find this in the book of (Psalms 34:4). At the end of the day, everyone has a past, and everyone has a story. I hope and pray that the chains were broken off your life by looking at a small glimpse of mine.

Volume 2 of this series will be released soon. There you will learn that you are not only somebody, but that you are the apple of God's eye; that God is a restorer; that he is a healer; that he is the mender of broken hearts; that you are worthy of love; that God has his best in store for you. It doesn't matter what it was, but what matters is what it is and what is yet to come. For are you not a virtuous woman whose price is far above rubies? (Psalms 31:10). Are you not valuable and rare? Are you not diligent and resourceful? Please know that everything

that the devil stole and tried to rob from you. God wants to give it all back to you. The enemy has to hand over your stuff! Please know that if God called you to it, He will get you through it. God has a purpose for your life and that is why it has been so challenging and so much warfare. Remember these words, Satan is defeated, his darkness is dispelled, and Jesus is still Lord.

Also, in Volume 2 of Hated Because of The Anointing, I will share what it's like to be hated right in the church of the Living God, all because of the Anointing, and because you refuse to compromise your oil. Also, how the spirit of Delilah, Jezebelle, and Peninnah are being portrayed right in the church house. I'm not here to tear the church down, because I love the church and I love the Lord. In addition to that, I am the church. Someone must be bold

enough to come forth and sound the alarm. I know that there may be others, but it will also be me.

I pray that this small portion of my life has touched your life. I know that it is not by mistake that you have read my book. We hear it repeatedly, that if you are in a domestic violent relationship of any kind, please seek help. Get out! There are resources that are available in every state throughout the country that can accommodate you with the things that you may need to find safety.

> There is also an 800 number for the National Domestic Violence Hotline that you can call 24/7 and that number is 1-800-799-7233 (SAFE). All information is anonymous, and your information will be kept confidential. Of course, if you are in immediate danger, call 911.

I was glad when they said unto me, let us go into the house of the Lord. (Psalm 122). I pray that you will become all that the Lord has called you to be. I believe that by faith and according to the Word of God, that you have already won this thing, because you are more than a conqueror through Christ Jesus. God is faithful, and he can do anything but fail. It may not have seemed that my prayers were being heard, but of course we know that he was there all the time. I cried unto the Lord, and he delivered me, and I am so glad about it. Never allow anyone to determine who you are, what your day will be like, nor what your future holds. You are the determining factor of that. You win! Glory be to God! You Win!

CLOSING PRAYER

So, Father, I thank you now for every person that has been encouraged and strengthen by just a small portion of my life. I know that you showed me that you were raising up a remnant, just never thought that I would be a part of that remnant, but I am eternally thankful. I trace back seven generations and break every contract, blood covenant, or word curse that has been spoken over your daughters and sons. I thank you Father that every chain, shackle, and yoke has been broken, and every burden has been destroyed off their life. Lord, we acknowledge that you are God, and we are coming to the throne of Grace so that we may

obtain mercy from you today. We make the declaration that any agreement that we have entered knowingly or unknowingly, every ancestral spirit that has been passed down through the blood line has been broken and destroyed by the fire of the Holy Ghost. Lord, we thank you for the lives that have been changed, and for those that have given their lives to you. We seal every word of this prayer under the blood. We come against every spirit of backlash and retaliation in the mighty name of Jesus. We do not take it lightly nor for granted that we are still here on today, and we give you all the glory, honor, and praise in Jesus' name, amen, amen, and amen.

ABOUT THE AUTHOR

Senior Pastor Dr. Von Brand was born in Birmingham, Alabama to the late Hosea Lee Herlong and Evangelist/Mother Josephine Herlong. I am the 3rd oldest of eight children, but the eldest daughter. I received Christ as my personal Lord and Savior at an early age and have been on the battlefield working for Jesus Christ ever since. My Christian values are reared of those through the Apostolic and I am eternally grateful.

I am a wife to my husband Robert, and the mother of 2 biological children, Jacquise and Antonio, and I am also the grandmother of 5 grandchildren. Trey, Josiah, Nakel, Madison,

and Zane. I am a Servant of God! I have served as a Missionary, Minister, Prophetess, and now am the Senior Pastor of Faith Apostolic Ministries.

I am a Certified Chaplin and Christian Counselor and Life Coach. A Co-Author of *AWOTM National Prayer Book: Praying for Everything Under the Sun*, and also the Co-Author of *What It Is Like Being A Woman*, by Dr. Tenaria Drummond-Smith and other Co-Authors.

I enjoy spending time with my grandchildren and my family who is my "first Ministry". I love, love, love my family and fellowshipping and being around the Saints of the most high.

HATED
BECAUSE OF THE
ANOINTING

CPSIA information can be obtained
at www.ICGtesting.com
Printed in the USA
BVHW041220130423
662288BV00014B/655

9 781955 107754